Richard and Friends

conversations I have with my dolls

by heidi corley barto

Snarky
Plastic

New York

Ricky and Friends:
conversations I have with my dolls

Copyright © 2017 by Heidi Corley Barto
www.rickyandfriends.wordpress.com
hcbdolls@gmail.com

Published by
Snarky Plastic
WIngdale NY

Book design, text, and pictures by:
Heidi Corley Barto

ISBN-10: 0-692-90605-3
ISBN-13: 978-0-692-90605-7
First Printing : 2017

- Thank you -

To all the people that have encouraged me
to share Ricky's stories and to keep working
on new adventures

To my family for their understanding when
our family vacation plans include a little
plastic person and her photoshoots

To the husband Ricky,
you are the most patient man in the world!
I love you XoXo
~ H

People : "How do you make up
these conversations?!"
Me : "I don't..."

Meet My Mom

Ricky : "This is Mom. She's not usually in front of the camera. Mom, I don't care what anyone says about you, I don't think you're weird!"

Me : "Thanks...?"

Ricky : "How long have you been doing this?? The whole picture taking, funky hair dyeing, talking to dolls thing...?"

Me : "Uhh... Most of it since 2014, I guess.."

Ricky : "So there you have it folks!! Her mid-life crisis started in 2014!"

Me : "OMG! No!! It did not!"

Ricky : "Was it earlier??!"

Me : "NO!! I'm not having a mid-life crisis!!"

Ricky : "Suuuure you aren't....
Anyways! Let's move on to some stories!"

Me : "Really smooth segue.."

Ricky : "I don't know what that word means but I have a feeling you were being sarcastic!"

Me : "Nooo.."

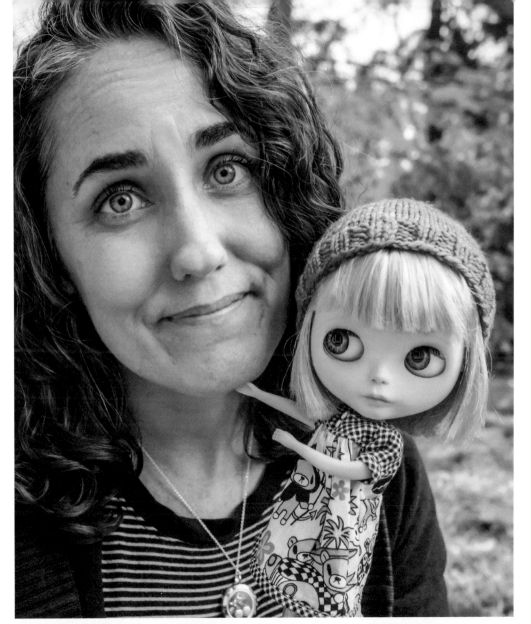

The Library Monkey

Me : "Uhh. What are you guys doing??"

Ricky : "Lupita is helping me get the funny books, Mom!"

Lupita : "She told me to stand here and then she climbed up me!! I didn't have a choice! She's like a monkey!!"

Me : "RICKY! Get down before you hurt yourself or poor Lupita!!"

Ricky : "Okay.... I'm coming down!
LOOK OUT BELOW!!"

Lupita : "She's crazy!"

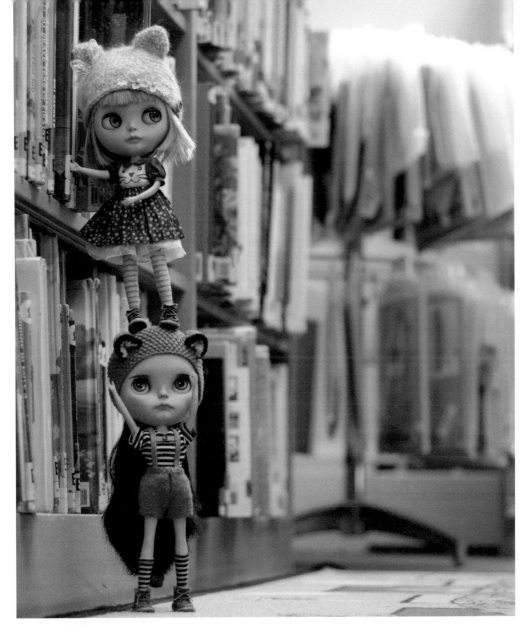

Jumping in the Leaves

Ricky : "Wooo hooo!!"

Chip : "HEY! Be careful you don't land on my head, please!!"

Me : "You'd better check each other for ticks when you're done.."

Ricky : "Wow, Mom.... Way to ruin the fun."

Chip : "I'm itching now... Check me, please??!!"

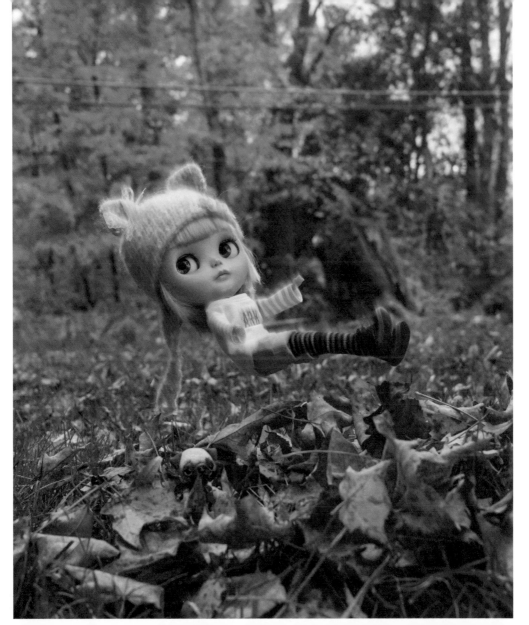

A New Guy

Ricky : "Mom. There's a little elephant guy in our yard!"

Me : "He arrived from NYC today. Our friend Lauren sent him to live with us. Isn't he cute?!"

Ricky : "He is!! What's his name??! He needs a name.. I don't want to keep calling him little elephant guy.."

Me : "What about E.G.?"

Ricky : "Ohhh.. I see what you did there..
E.G. for Elephant Guy. Yeah..
I'm too lazy to say an E and a G.
I'm just gonna call him Egg for short."

Me : "Egg the Elephant?"

Ricky : "Yeah. You got a problem with that??!"

Me : "Nope."

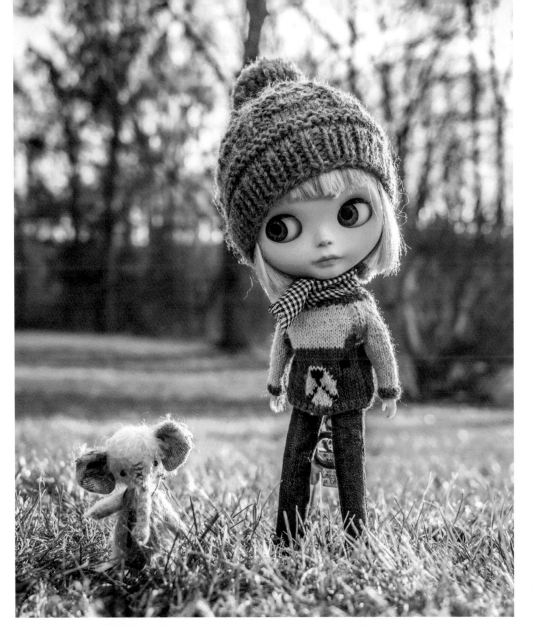

Cookie Monster

Me : "Ricky? Have you seen the cookie Holly Chan gave us yesterday? The one with the orange sprinkles?"

Ricky : "Nope."

Me : "What's that in your lap then?
It sure looks like orange sprinkles..."

Ricky : "That would be pumpkin poop! EW!
He must have gone potty on me!! Bad pumpkin!!"

Me : "So that's pumpkin poop on your lip too?!"

Ricky : "I guess it must be because I sure didn't eat that owl cookie!"

Me : "I never said it was an owl cookie....?"

Ricky : "Uhhh..."

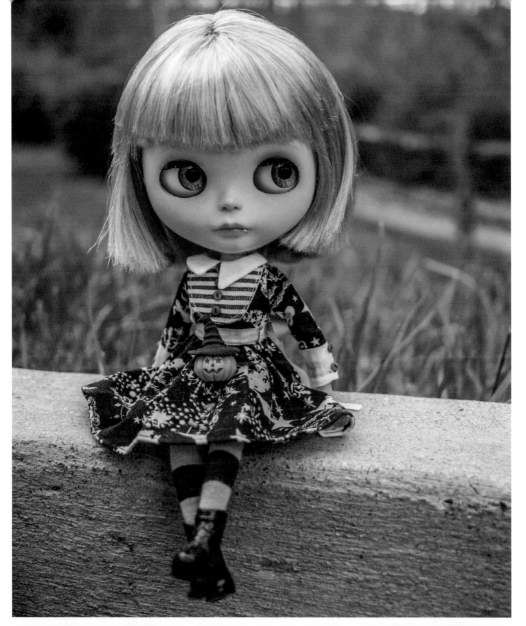

Happy Halloween

Ricky : "Mom... I think it's time for us to leave this hotel.. There's some strange things going on here...."

Me : "It's Halloween. Strange things always happen on Halloween."

Mirror Ricky : "She's right. We just need to make it through today and tomorrow we'll all be back to normal..."

Ricky : "We...??" ((whispers)) "pssst...mom.. help me."

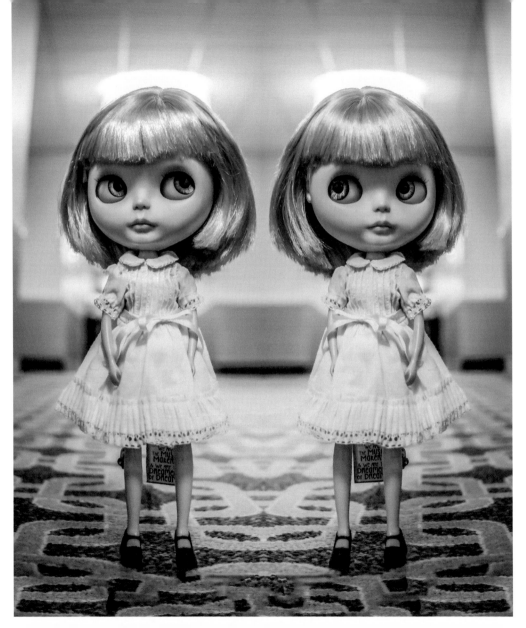

Dad's Birthday

Ricky : "It's your birthday today, right Dad?!"

Dad : "Yup! It's my day! I'm 49 years old!"

Ricky : "Isn't that the age where you have to watch what you eat and stuff?? You should probably stay away from desserty foods, I think.. That way you will make it to 50 years old.."

Dad : "You aren't eating the whole cake, Ricky... It's MY cake.."

Ricky : "I'm just looking out for your health, Dad... I know it's your day, but there's no need to be selfish..."

Dad : "Sorry..."

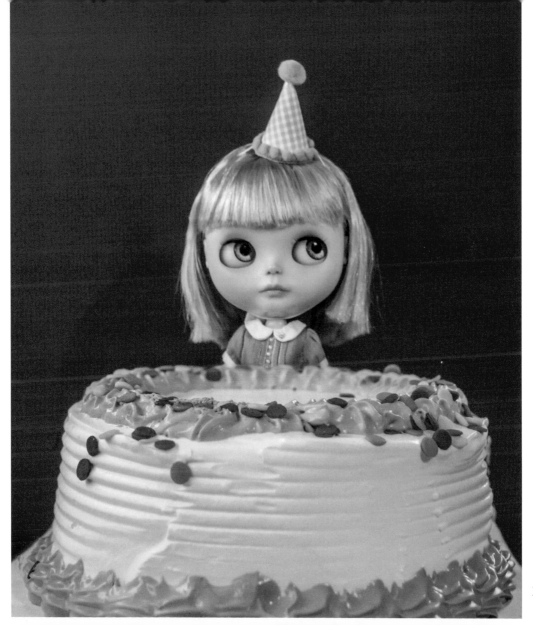

Libraries are Cool

Me : "Girls? Girls??! The library is closing and we have to go home..."

Ricky : "Lupita.. Don't tell her where we are..."

Lupita : "Why??"

Ricky : "We don't have central AC at home..

It's a 100°F outside! That means it's going to be almost 90° in our house! It's nice and cool here. I don't want to go home."

Me : "GIRLS?? WHERE ARE YOU??"

Lupita : "WE'RE NOT OVER HERE!"

Lupita : ((whispers)) "Was that okay, Ricky??"

Ricky : "Omg, Lupita.."

Me : "Found you!! C'mon! Let's go!"

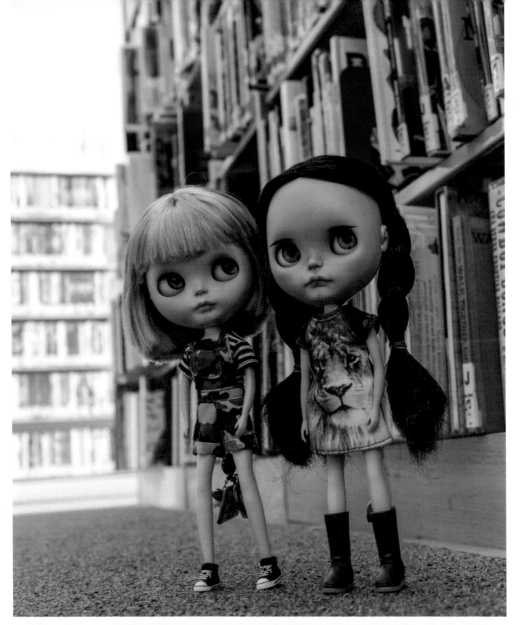

Safety First

Ricky : "Mom. Me and Chip are gonna go for a bike ride."

Me : "And is he going to hang off of your handlebars like that?? That's not very safe..."

Ricky : "We've been practicing. I say, 'kick Chip, kick!!' and he swings his little feets up so they don't get caught in the spokes!!"

Me : "You've been practicing??!!"

Ricky : "Yeah.. He makes a pretty good bell, too. I think he's trying to sound like a bell... Maybe it's a cough.. Do those straps look too tight to you??"

Me : "Oh geez.."

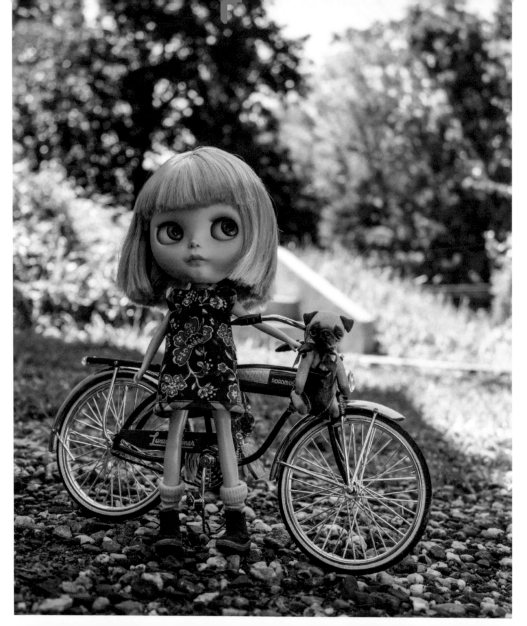

Our Town Rocks!

Ricky : "Mom.. I found this pretty rock in the garden.
Where do you think it came from??"

Me : "There's a group of people that are painting pretty pictures on
rocks and hiding them around town for people to find!
Congratulations on finding one!"

Ricky : "Do I win a prize??"

Me : "No... But there's a few things you can do. You can keep it,
but if you do you should paint another rock and hide it for someone
else to find, or you can hide this one somewhere else."

Pigeon : "I think you should keep it, Ricky. I'll help you paint another
rock and we can hide it together! Mom?? Where can we buy a rock to
paint??!"

Ricky : "It's a rock, Pigeon... Why would we buy a rock??!
We live in the country."

Pigeon : "Ohhhhhh.. Yeah.."

Macaron Sonny : "It's Wiener Wednesday! We could paint a picture of
my..."

Me : "OH AND THERE'S ONE MAJOR RULE! No dirty pictures on the
rocks. They must be kid friendly. What did you want to paint on the
rock Macaron..??"

Macaron Sonny : "Nevermind.."

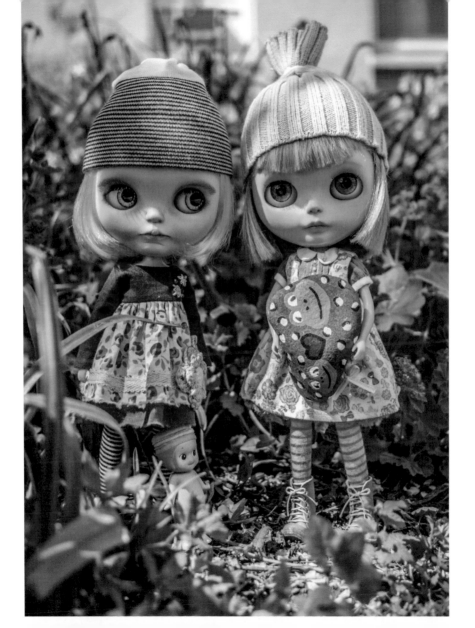

Rock Pushers

Ricky : "C'mon Daisy! We gotta get this painted rock to its hiding place!"

Daisy : "Why did you paint such a big rock, Ricky?? It's heavy!!"

Ricky : "It's the perfect rock! I saw it, and it looked like a heart, so BAMM!! I painted a heart on it!"

Frenchie : "He he he... You said 'heart on it.' 'Heart on' ... that sounds like 'hard....'"

Ricky : "FRENCHIE! STOP! Think clean thoughts!"

Daisy : "How much farther??!!"

Ricky : "Ohh... Three more miles maybe..?"

Daisy : "Yuck!"

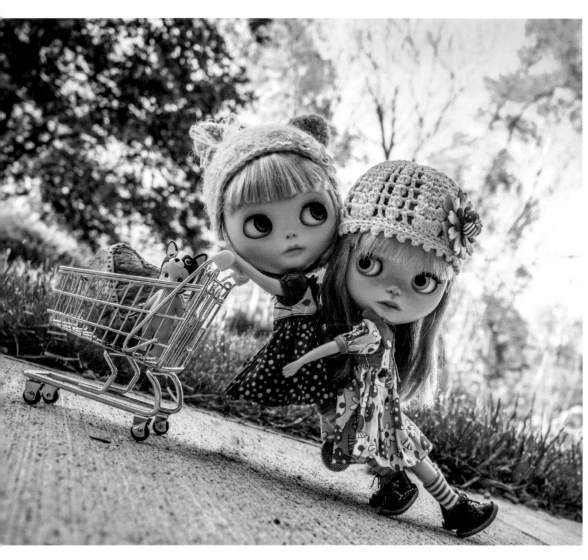

And The Morel
of The Story Is..

Ricky : "Mom.... I think I found a bee house.. Don't move!"

Me : "That's not a bee house!! It's a mushroom."

Ricky : "It's obscene! I'll bet it's full of poison! Our yard is a death trap! AHH!"

Me : "People actually pay money for these ones. They eat them."

Ricky : "Are you gonna eat it??!"

Me : "Nooooo...."

Ricky : "Chicken."

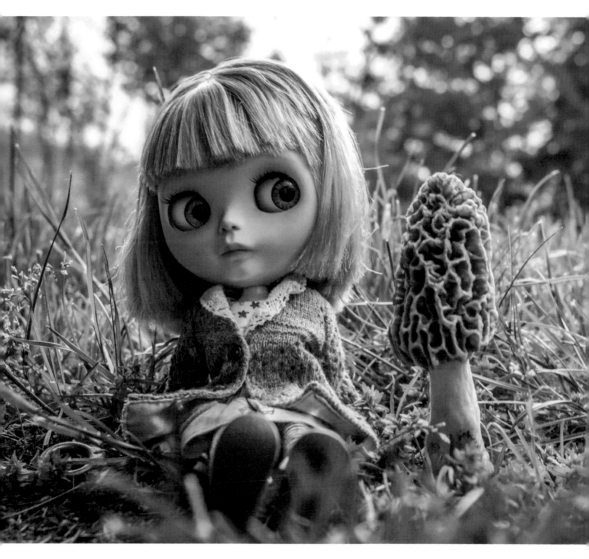

Winter is Coming

Ricky : "What's the temperature, Mom?"

Me : "The thermometer said four degrees this morning.."

Ricky : "Forty?? It feels colder than forty..."

Me : "Not forty... FOUR. Four degrees. I think it's up to eleven degrees now. Tomorrow is the first day of Winter."

Ricky : "I think Winter is like one of those people that you invite to a party, and you tell them the party starts at 5pm on a Friday, and they show up at noon the Wednesday before!!"

Me : "Yup."

Another New One

Ricky : "What's this?? Another new kid??!! She's wearing my socks and shoes, Mom!!"

Me : "This is Minka! You can share your socks and shoes with her. Her feet are actually a little bigger than yours..."

Ricky : "So, she's stretching out my shoes then??!! Awww!!"

Egg the Elephant : "I think she's got your scarf on too, Ricky..."

Me : "Omg. I have clothes for her on order! You'll get your stuff back soon, I promise."

Minka : "Hi Guys!! Ricky, are these your underpants I'm wearing?? I like them but they're a little big..."

Ricky : "Gah!"

Spelling Bee

Egg : "How do you spell Elephant??"

Ricky : "E-l-l-e-e-f-a-n-t."

Egg : "That's not how the dictionary spells it!!"

Ricky : "You didn't ask me how the dictionary spells it!!"

Sonnyman
or Snowangel??

Ricky : "Uhhh.. Egg?? While we admire your attempt at building a snowman..."

Lupita : "We think you should stick to just using snow when you build them, okay?."

Ricky to Lupita : "Should we be worried about this??"

Lupita : "I don't know..."

Don't Touch the Puffs!

Ricky : "See these cream puffs?! Mom made them for a work party she's going to without me! Our whole house smells like these delicious puffs and chocolate and chocolate mousse!!"

Me : "You had better not be touching those puffs!!"

Ricky : "I'M NOT TOUCHING THEM! I'M LOOKING AT THEM AND BEING SAD!! Do you know how many you have..??"

Me : "I not only know how many, I know how much they weigh! So if even so much as a drizzle of chocolate is missing, I'll know!"

Ricky : "Gah!"

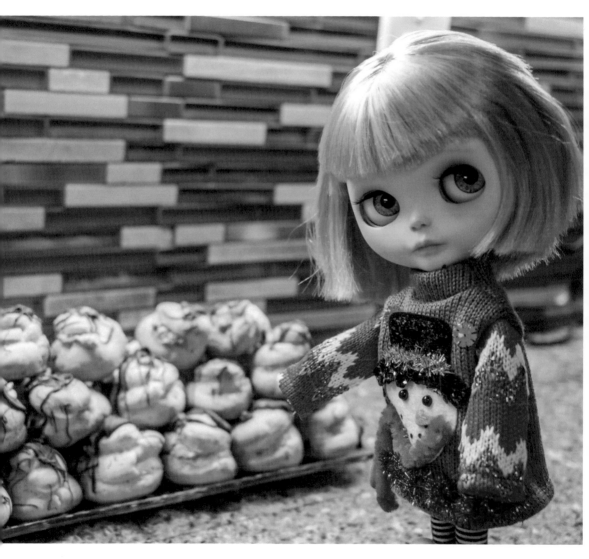

Christmas Digs

Ricky : "Hey, Lupita! What's that saying.. 'The higher the hat, the closer to God?!' Hahahahahaa!!!"

Lupita : "Actually the saying is 'hair' not 'hat' and by the way, 1985 called... They want their leather pants back!! AHAHAHAHAAAAAA!!"

Me : "Just because you girls are wearing ugly Christmas sweaters, it doesn't mean you should ACT ugly!!
Santa's watching by the way.."

Ricky : "I love you, Lupita! That hat makes your big head look really pretty!"

Lupita : "And I love you too, Ricky! Your leather pants make such beautiful fart noises when you sit on our
leather couch! Is that better, Mom??"

Me : "Ehhhh, not really..."

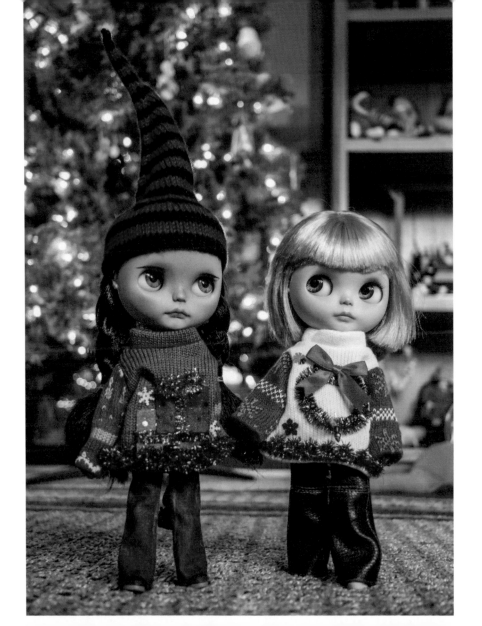

In The Holiday Spirit

Ricky : "Today we went shopping to buy some gifts.
My Dad says that sometimes Santa has a hard time finding
some kids and we have to help him out. It's not fair if they
don't get gifts on Christmas just because Santa has crappy
GPS. Anyways, we bought these gifts. They are going to a
little boy. These things were on his Christmas list, so we
bought them. I wrapped them myself."

Me : "Ricky... I think you may have to make another tag...
I don't think writing 'To Stranger Boy' was a good idea.."

Ricky : "Mom. He's a stranger and he's a boy..
I did write that I was his friend.
Is that okay??"

Me : "Yeah. That should be okay."

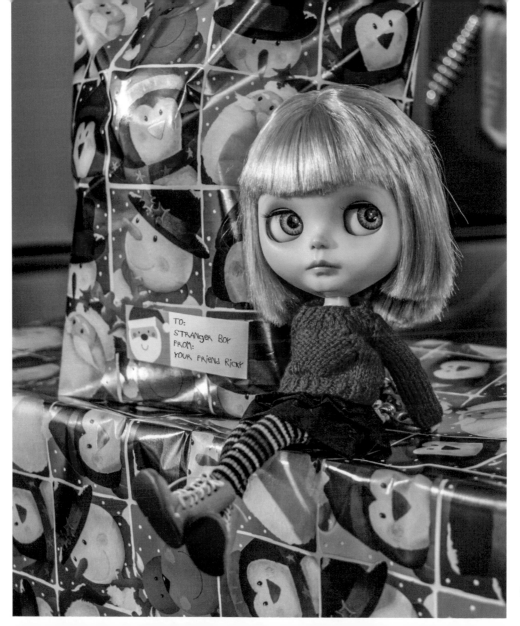

TO:
STRANGER BOY
FROM:
YOUR FRIEND RICKY

Quality Control

Daisy : "MOM! What are you doing in the kitchen..?"

Me : "Well... I was checking to make sure you girls weren't getting into anything.."

Ricky : "Nope. We're not getting into nothing! We're just checking these cookies you put out for Santa. They look good! This one passes inspection! A+"

Daisy : "Yep. What Ricky said. That's what we're doing! We're cookie inspectors!"

Me : "And what about the eggnog? Did that pass inspection too? Ricky??"

Ricky : "Oh! Should I test that? I guess I will If I have to..."

Me : "I know you already did. Your milk mustache gave you away.."

Ricky : "Darnit!!!"

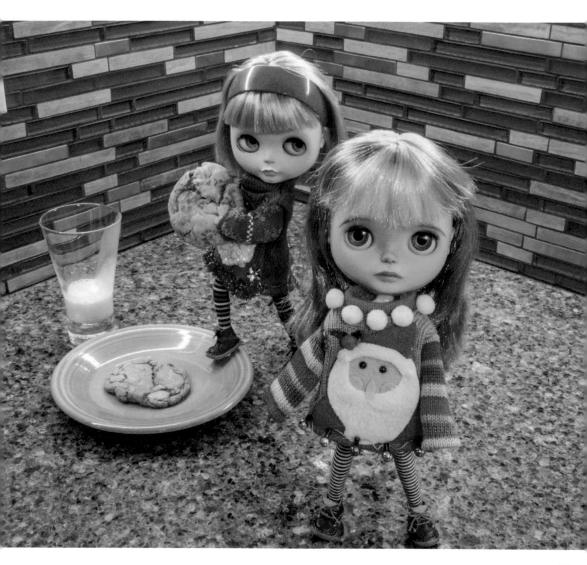

Looking for a Rescue

Ricky : "Ohh. Look at all these pups, Chip!"

Chip :

Ricky : "There are so many dogs that need rescuing!
Here's a girl one! She could be your girlfriend, Chip!
Woo hoo! Chip could have a girlfriend!!"

Chip :

Ricky : "Seriously, Chip?? I had no idea!! Well maybe this
little fella is more to your liking then..
He's very handsome."

Chip :

Ricky : "Yes... I agree. His eyes are very dreamy."

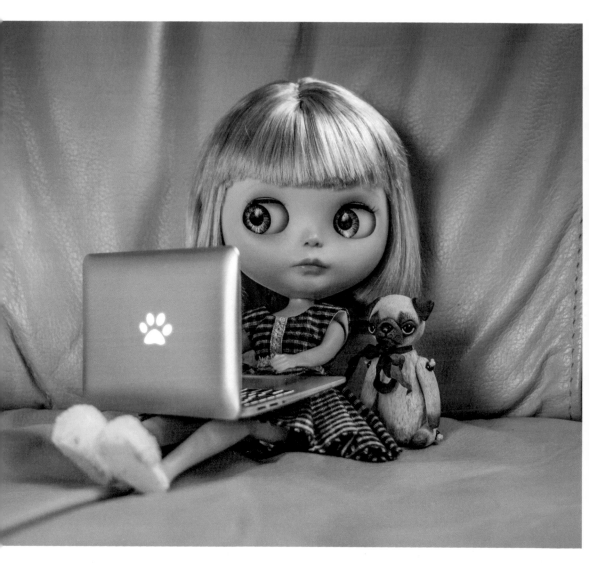

In Your Dreams

Ricky : "Mom.. I had a dream that I was all snuggled up next to that boy puppy we saw online. He was very cuddly and every once in a while he would lick my nose!"

Me : "Awww. That sounds like a really good dream."

Ricky : "Have we heard back from the puppy rescue place yet??"

Me : "No. Not yet."

Ricky : "Wake me up if you hear anything, okay?? I'm going to go nap and see if I can snuggle that puppy again."

Me : "Okay."

These Are Our Demands!

Me : "Ricky? You writing a letter to someone??"

Ricky : "Yeah... I'm writing to the doggy rescue place. I'm telling them we want that boy dog. That we are a doggy family without a dog to love. He would have a very good home with us."

Me : "That sounds nice..."

Ricky : "Yes. And I also said that they need to hand him over by 5pm tomorrow or else!! Then I drew a mean face!"

Me : "Uhhh... I think you should leave that last part out!"

Ricky : "Which part??"

Me : "The threatening part AND the mean face drawing!"

Ricky : "Okay, but if we don't get him it's your fault..."

Me : "..okay.."

47

Ricky to the Rescue!

Ricky : "See that derpy little pup there?? That's my new brother!! We pick him up on Saturday. He's far away in New Jersey. He's a rescue dog and he's in a foster home right now. His description says super smart and high energy. I think that means he knows how to get into things! Lots of things!"

Me : "And his name is Dallas!"

Ricky : "Just like Dad's favorite football team, The Dallas Cowboys!! Dad is very excited to have another boy in the house. He's been the only one forever! Dad says Dallas will watch football with him and they'll hike the Appalachian Trail together!"

Me : "And we will have to very patient with Dallas. Coming to a new home with new people is going to be very scary."

Ricky : "I'll be patient. If he poops in the house I won't even yell! I'll quietly tell you to clean it up."

Me : "Thanks.."

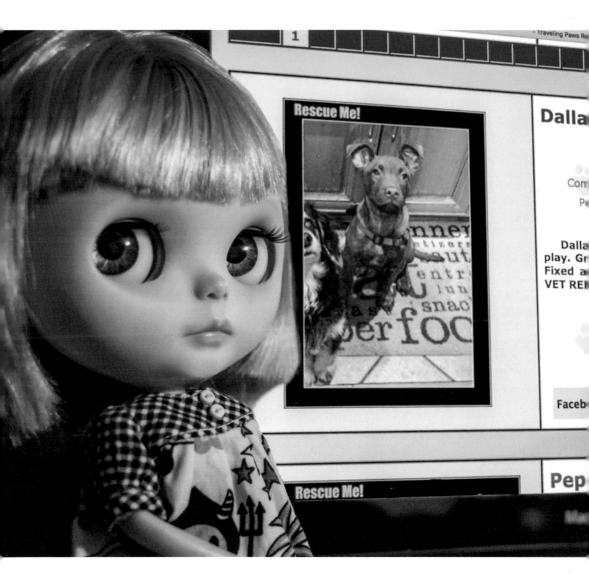

Dallas is Home!

Ricky : "This is my brother Dallas. He's making himself right at home. He likes getting his picture taken, but wasn't sure about me.. He tried to grab me by the hair!!"

Me : "Dallas is a baby. He has to be told that hair isn't food."

Ricky : "He's giving you the stink eye, Mom!
That reminds me of our other pup Sophie. I love him."

Me : "He's a good boy."

Ricky : "Yeah. His ears are ridiculous!"

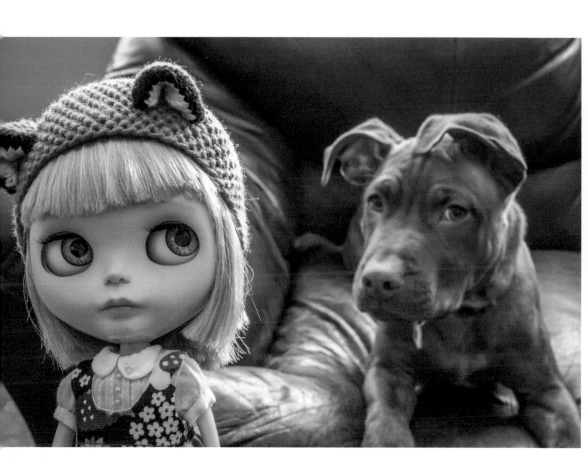

Big Boy Teeth

Ricky : "Guess who is getting a visit from the tooth fairy tonight?! DALLAS!! He was making a funny lip smacking noise last night and Mom realized one of his puppy teeth was loose! Today it's gone!! We think he ate it! Mom's gonna get it out of his poop so we can give it to the tooth fairy!!"

Me : "EW! NO I AM NOT!!"

Ricky : "MOM! If we don't have a tooth the tooth fairy can't come!!"

Me : "She'll still come. We can write her a note. Wait... Since when does the tooth fairy come for doggy teeth..??!"

Ricky : "That's discrimination Mom.."

Me : "Omg..."

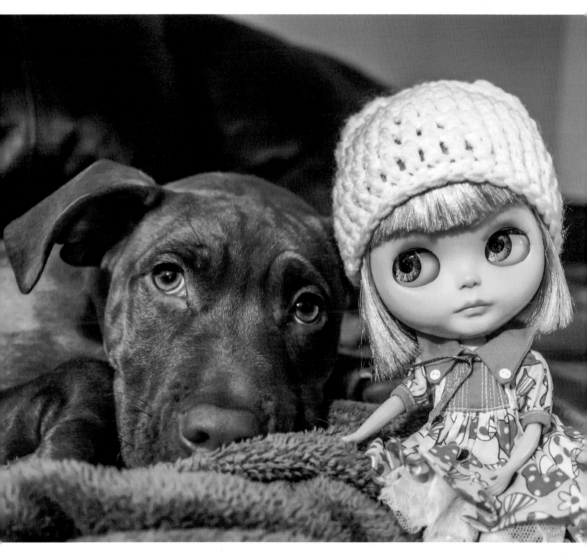

Spit and Polish

Ricky : "MOM! Dallas tried to do my hair with his tongue!!"
Me : "EWWW!!"

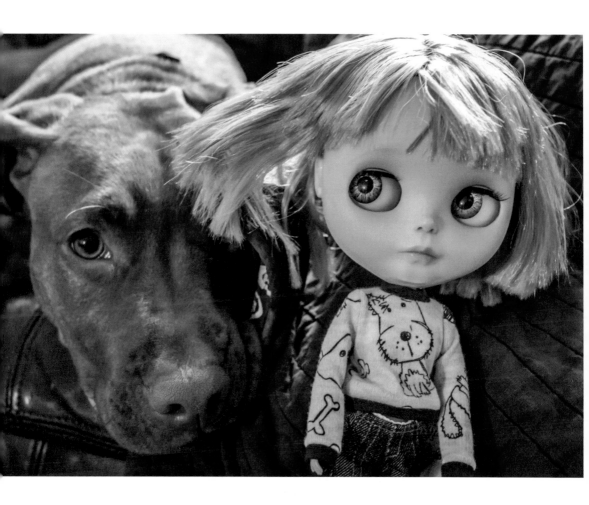

It's (not) My Birthday

Ricky : "This new dress came in the mail today and I think it goes perfectly with this hat I got in San Francisco..
The only problem is, when I stand outside and wave at people, they're yelling 'Happy Birthday' at me!!
It's not my birthday.."

Me : "Did you tell them it's not your birthday??"

Ricky : "Noooo. If they come back with presents, I'll tell them after I open them."

Me : "I doubt anyone is going to come back with presents.."

Ricky : "You don't know that, Mom.. Do we have an air horn?? More people will see me if I had an air horn..."

Me : "No, we do not have an air horn and I have no plans on ever getting one."

Ricky : "Okay.. I'll just keep yelling and waving then..."

The Blind Photographer

Me : "Stand still, girls! You're going to make the picture blurry!!"

Ricky : "I'm not moving!! Are you guys moving??"

Daisy & Lupita : "Nope."

Ricky : "Mom. None of us are moving!! It's your eyes making us look blurry!! Your pupils are huge!!"

Me : "Yeah. The eye doctor dilated them during my eye exam.. I can't really see..."

Ricky : "How the heck are you going to take a picture then if you can't see??!"

Me : "I can sort of see.. It'll be fine.. Don't move!!"

Ricky : "Ugh."

Bad Babysitter

Me : "RICKY!! What happened to Squish??!!"

Ricky : "I don't know.... She looked like that when she got here.."

Can You Help a Duck?

Me: "What are you guys doing outside?? It's pouring rain!"

Ricky : "Mom. These guys said to me, 'Ricky, we are sad ducks! We never get to go outside and play in the rain! We want to play in a big puddle!' I HAD to bring them outside!"

Me : "But there's no big puddle here... You should go back inside.."

Ricky : "Mom. We're going to wait for this puddle to get bigger. It's not cold outside. Can we wait for this puddle to grow, please?? I don't want them to be sad.."

Me : "You can stay out just a little bit longer. You're a good ducky friend."

Ricky : "Thanks Mom."

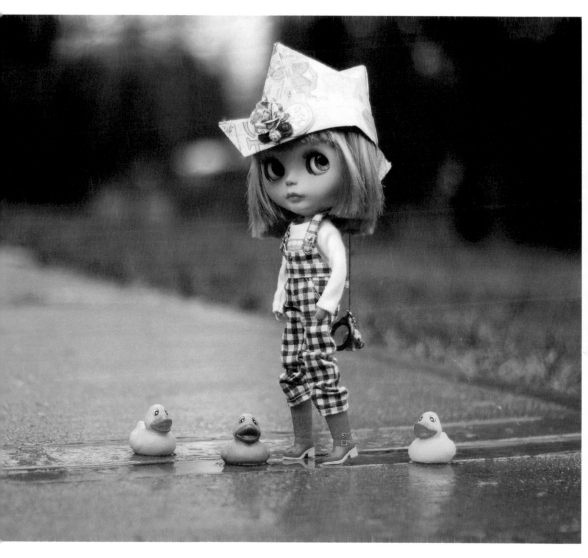

Schrödinger's Store

Ricky : "Oh. My. GOSH! MOM!! The name of that place is Peas and PICKLES!!! They've got a whole store filled with peas and pickles!!!! LET'S GO IN!!!!!"

Me : "It's just a grocery store, Ricky.. I'm sure they have other stuff besides peas and pickles..."

Ricky : "But do you really know that??! Have you ever been in there in your life??!!"

Me : "No. I haven't."

Ricky : "So if we don't go inside, we are both right, right?! The store is a regular grocery store AND it's filled with just peas and pickles!"

Me : "My head hurts.."

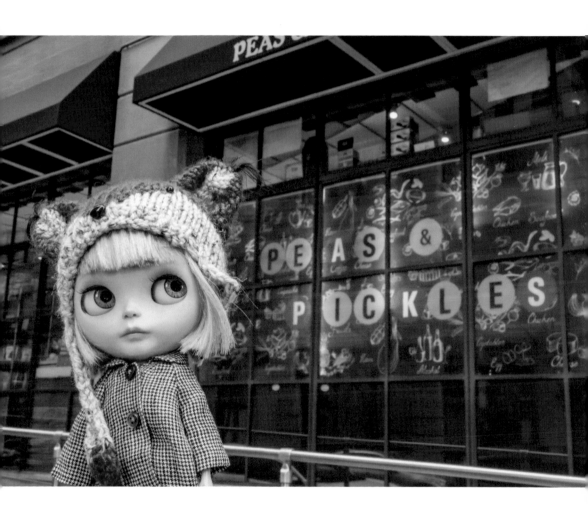

Via Santa Croce Milano

Ricky : "Hey Mista' Italy man! What's 'da matter?? You never seen a lady taking pictures of da' little people before??!!"

Me : "Omg! Why are you talking like that??!"

Ricky : "We're in Italy! I'm speakin' Italian! Bada boom, bada bing!"

Me : "That is NOT Italian, Ricky.."

Ricky : "Are you sure..?"

Me : "I'm positive."

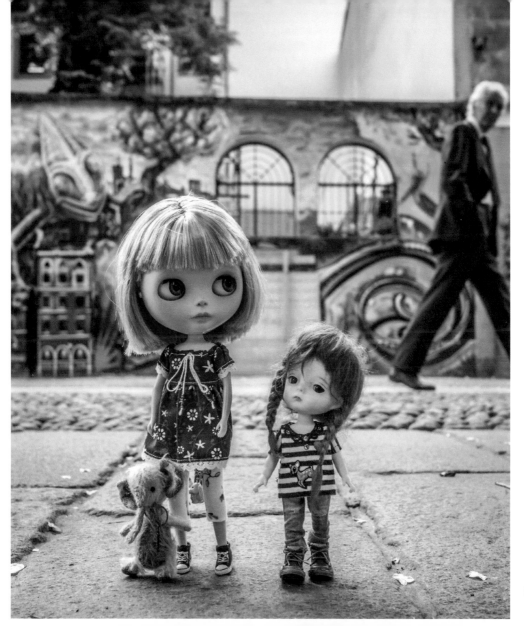

Duomo di Milano

Ricky : "Mom, can you tell all these people to get out of the way?!! I'm trying to pretend I'm living back in the olden days but these tourists are ruining the mood!"

Me : "You're a tourist..."

Ricky : "MOM!"

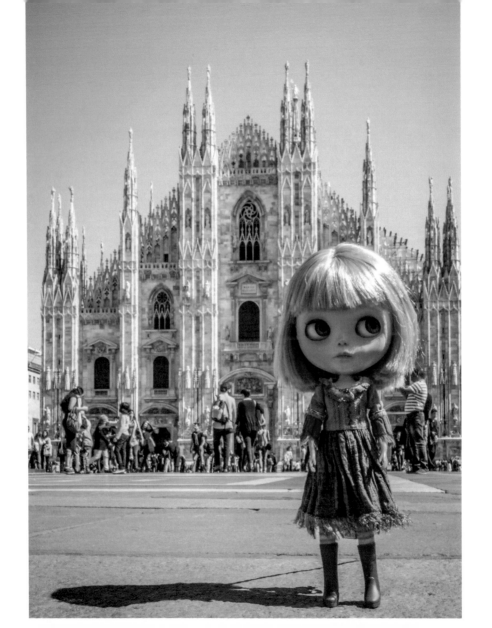

At The Drive In

Ricky : "It's the new season for the Drive In!!
WOO HOOO!! WE'RE GOING TO WATCH ALL THE MOVIES!!"

Nell : "RICKY!! Shhhh! We didn't actually buy tickets to get in...."

Minka : "Mom smuggled us in in her market basket....
We're such rebels."

Egg the Elephant : "You guys know that kids are free, right?! You don't have to buy tickets.."

Ricky : "So we could have just driven in like normal people instead of being crammed in that basket??!!"

Egg the Elephant : "Yup."

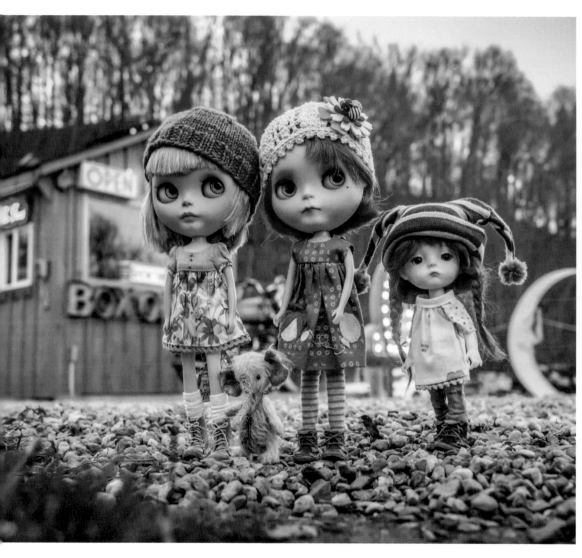

Wishful Thinking

Ricky : "Mom, I think you're dandy, and I'm not lion!!"

Me : *groans*

Ricky : "Mom..? When some people look at
a field of dandelions, they see a hundreds of weeds..
You know what I see?"

Me : "What do you see?"

Ricky : "A thousand wishes!
I wish for you to have a great day!!"

Me : "Aww.. Thank you!"

Ricky : "It's the least I could do!
I still have 999 wishes left!
I'm gonna get so much stuff!! WOO HOO!"

Me :

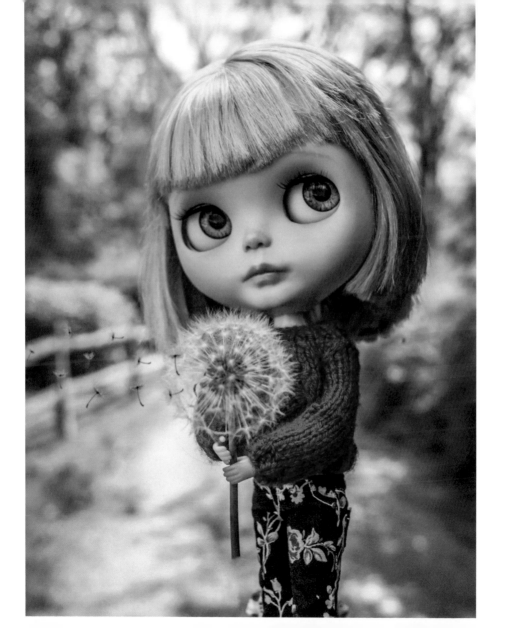

Ricky of Green Gables

Ricky : "You hear that ruckus??!
I think I'm being followed!"
Me : "Maybe.. Who do you think is following you??!!"
Ricky : "I'll bet that it's Cornwell, The Bunny King!!
See my purse?? That's his sister Lois! Well... not all of
her.. just her HEAD! He wants revenge so he's hunting
me down!! He's a master tracker! I must go jump in a
river to cover my scent!"
Me : "Your imagination is running away with you!!
No more watching Anne with an E on Netflix!"
Ricky : "Oh, why must you plunge me into the depths
of despair! This is the most tragical thing that has ever
happened to me!"
 Spins and faints daintily onto a bed of moss
Me : "Omg."

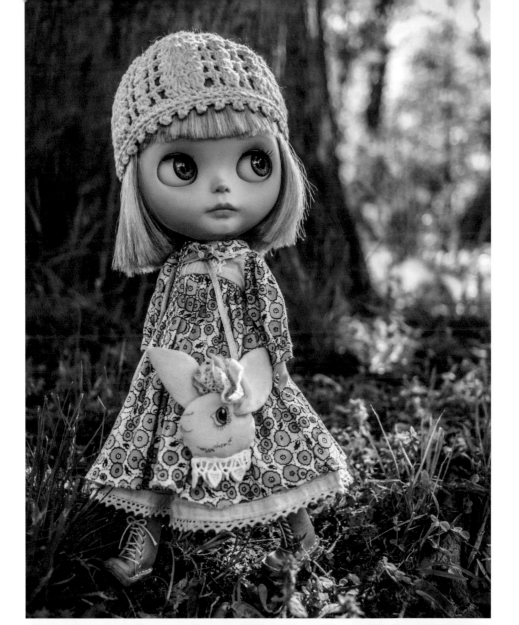

Rub A Dub

Sailor Sonny : "Ricky...? You invited me to swim in the bubble sink with you but you didn't say you were bringing a friend... Who is this baby lady?"

Ricky : "That's Sara. She's a forgotten toy. Aunt Bethany wants Mom to fix her up so she can give her to her daughter Squish to play with... So she'll be loved again."

Sailor Sonny : *sniff, sniff* "What is that I smell??!"

Ricky : "Sara has a mild case of the mildew. It's something that happens to the elderly..."

Sailor Sonny : "oh... I think I may just swim next time... The water's looking a little murky.."

Ricky : "Yeah.. I may do the same."

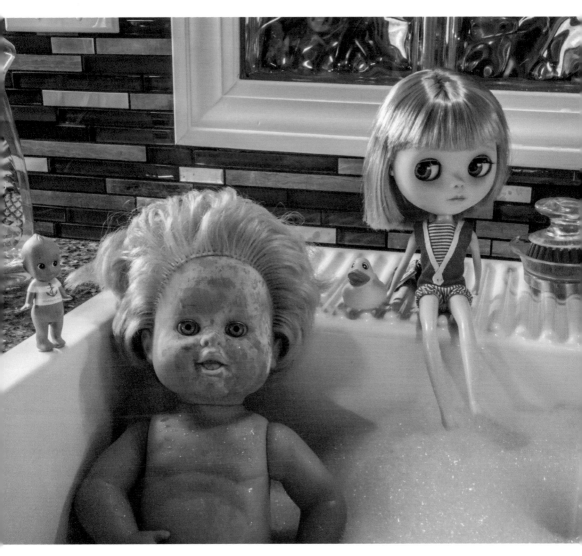

Strike One!

Ricky : "Is it true that lightning never strikes the same place twice?"

Me : "I think that's a myth.."

Ricky : "Noo... It looks like it hit something over there! Defnitely not a miss!"

Me : "I said MYTH, not miss!"

Ricky : "Ohhhhhh... I thought you had a lisp! So can it strike the same place twice??!"

Me : "Omg... YETH! GAH! I mean YES!!"

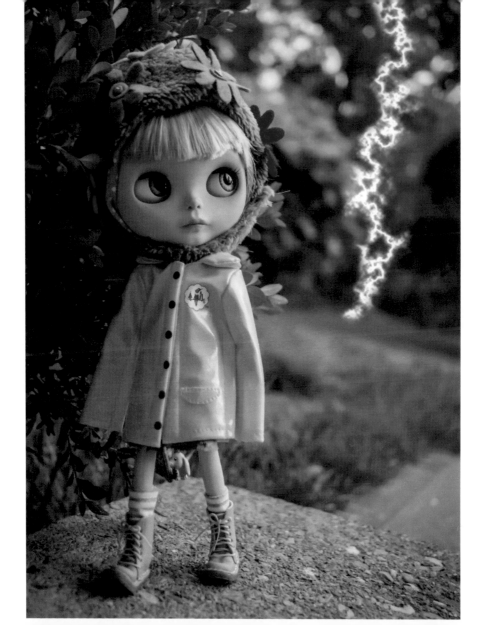

Fair Trade

Ricky : "Mom, do you like my hat??! Me and Pigeon did a trade.."

Me : "Oh you did, did you?! So what did you give Pigeon for her bunny hat?"

Ricky : "I gave her a pair of my underwear."

Me : "Whaat??! Ew!"

Ricky : "Mom! She didn't have any on! She was flashing everyone every time she tied her shoe!"

Me : "We have extra underwear..."

Ricky : "Shhhhhh.. I don't want to give the hat back!"

Me : "Ricky!"

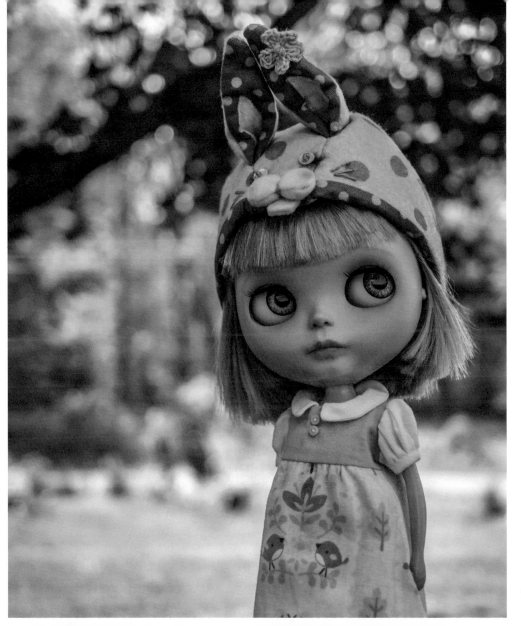

Don't Wanna Walk!

Ricky : "Brooks! I'm taking you for a walk. That means YOU need to walk. I'm not carrying you. Mom said I can adopt you only if I took care of you and that means going for walks.."

Me : "He may be tired.."

Ricky : "Oh. We did have a long day outside.."

Me : "We did. You're doing good job being a doggy mama so far."

Ricky : "So you aren't going to take him away 'cause he won't walk??"

Me : "No. Keep trying. He'll want to walk once he's rested a bit."

Ricky : "Okay. Whew! I didn't want him to leave because I love him already! He's a good boy!"

Me : "He is."

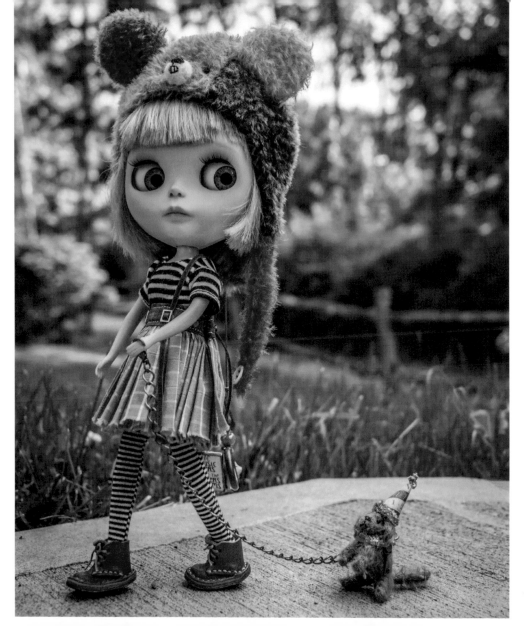

Ricky's Ride

Latte : "What kind of bike do you have?"

Ricky : "It's a Roadmaster."

Latte : "Dang! Cherry red with chrome fenders... lucky! You ever take it off any sweet jumps?"

Ricky : "Yeah... sure I have.. I have trophies and stuff."

Latte : "Can you do one now??"

Ricky : "WHAT DID YOU SAY MOM?? I HAVE TO COME BACK INSIDE?? OKAY!! I'LL BE RIGHT THERE! Bye Latte, I gotta go. My mom is calling. See ya'!"

Ricky rides off towards home

Latte : "..I didn't hear anything..."

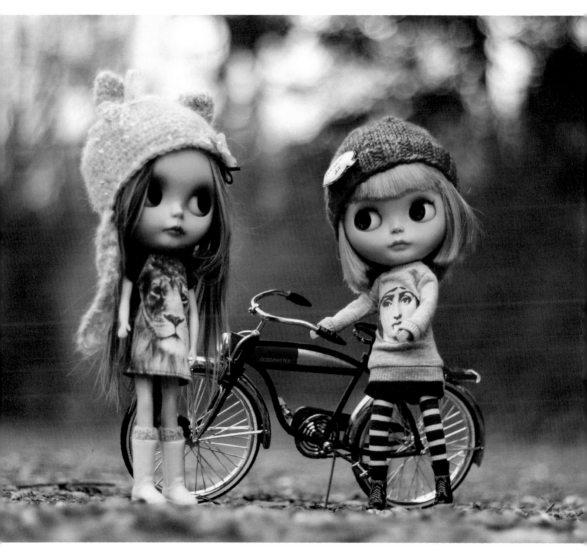

Communication

Ricky typing frantically

Lupita : "Did you seriously just message me over the computer..??!!"

Ricky : "Yes.."

Lupita : "I am sitting right here! You can't just talk to me?!"

Ricky : "But when I do it this way, I can send you cute stickers and emoticons. Nothing says 'Hi' quite like a waving puppy eating a cupcake and riding a unicorn."

Lupita : "That says hi??"

Ricky : "..uh YES. He's WAVING! Durrr."

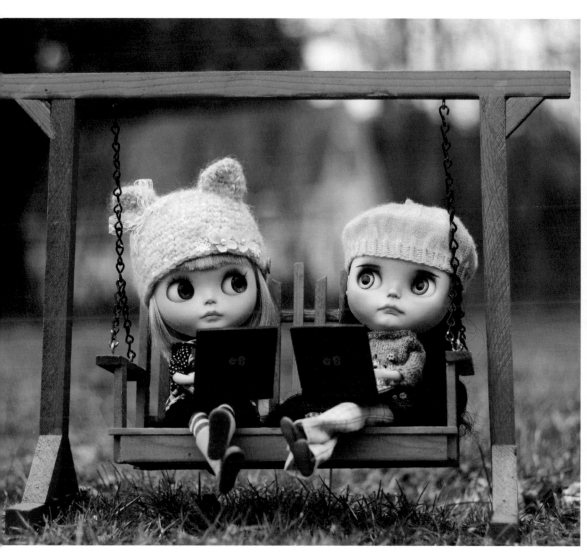

All The Marbles

Darla : "Ricky? How come you let me have all the pretty marbles and you took the plain one??"

Ricky : "Darla, I get the pretty stuff every day...
Today it's your turn. Plus this marble isn't really plain.
It has history. Grandpa Corley found it buried in the yard when Mom was a kid."

Darla : "Ohhhh. When Mom was a kid??!! That makes it an antique!!"

Ricky : "Yup."

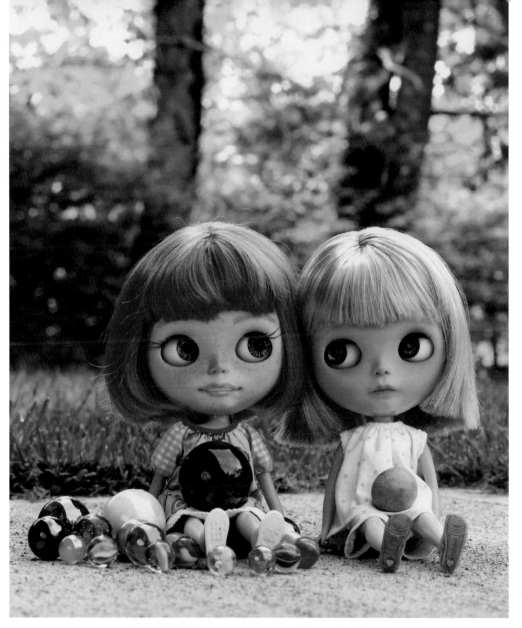

Ricky's Red Tractor

Ricky : "My tractor's here and I'm ready to ride!"

Me : "Where did that tractor come from??!"

Ricky : "Did you see those farmer guys at the fair??
They had lots tractors and they had signs on them that said
0% interest and that you could take years to pay.."

Me : "uhhhhh, yeah. I saw those guys..."

Ricky : "And remember when you went to go pee and left me
with Dad..? Well, Dad was looking at his phone and not
paying attention, so went I over and bought this tractor!
We have 6 years to pay it off. I'm figuring I'll have a job by
then... maybe.."

Me : "Ugh. Wait till I see your father..."

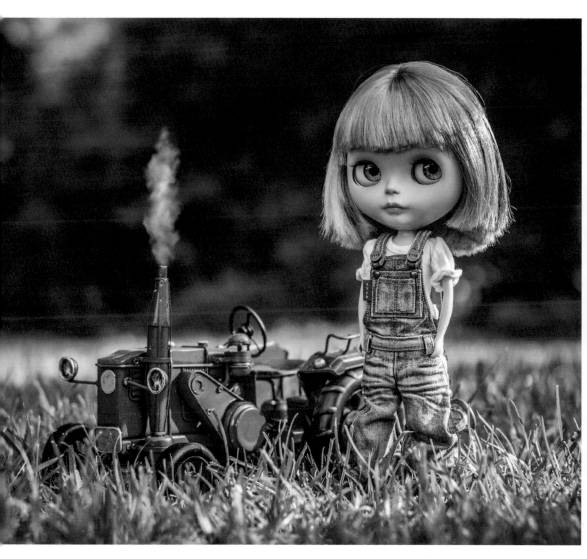

Lupita's Adoption Anniversary

Ricky : "Mom. Lupita arrived here from Scotland one year ago today! As an anniversary gift to her, I told her she can take out any books in the library and keep them for three whole weeks!! Using her own library card of course.."

Me : "Wow... That's super generous of you..."

Lupita : "She's making me take out all the books that SHE likes..."

Ricky : "Because I know all the good ones, Lupita!"

Frenchie to Lupita : "Are you a library book? Cause I'm checking you out..."

Lupita : "Ew. Stop."

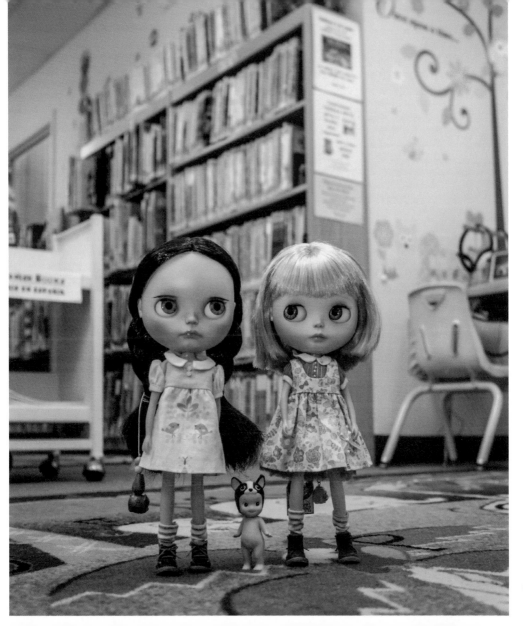

If You Give
a Moose a Muffin

Ricky : "Mom... Remember when that moose came through town??!"

Me : "Of course I do! It was only three days ago! I'm sure he's long gone by now..."

Ricky : "I wouldn't be so sure... Do Mooses eat cereal? Or Pop Tarts??"

Me : ((sees moose)) "Uhhhh, I have no idea... I read somewhere they like muffins..?"

Ricky : "Ok cool."

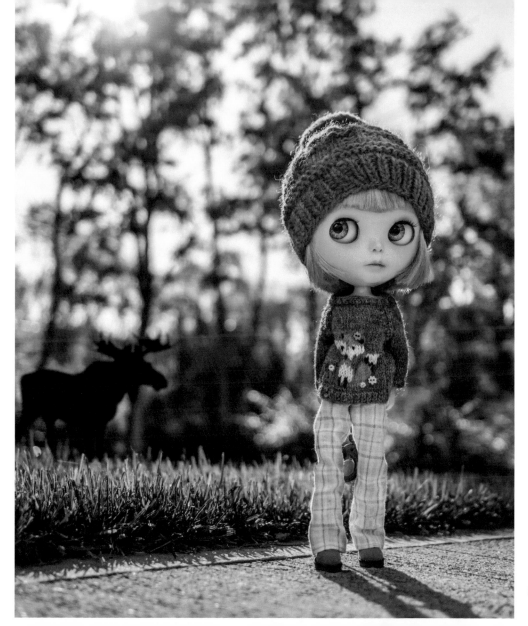

All Dressed Up

Pigeon : "Ricky! Stop picking your butt!"

Ricky : "I can't help it! Whenever Mom is taking a picture it's like there's a stick jabbing me back there!"

Lupita : "I know what you mean! I gotta pick mine too! Pigeon, you may want to check yourself too. Your dress is super crooked!"

Pigeon : "Ugh."

Me : "Girls! We're getting ready to go out to eat at a fancy restaurant. Please stop fidgeting and quit picking your butts!"

Ricky : "I'm gonna do it right when the waiter comes over!!"

Me : "No. Butt pickers get no dessert!"

Ricky : "awwwww....."

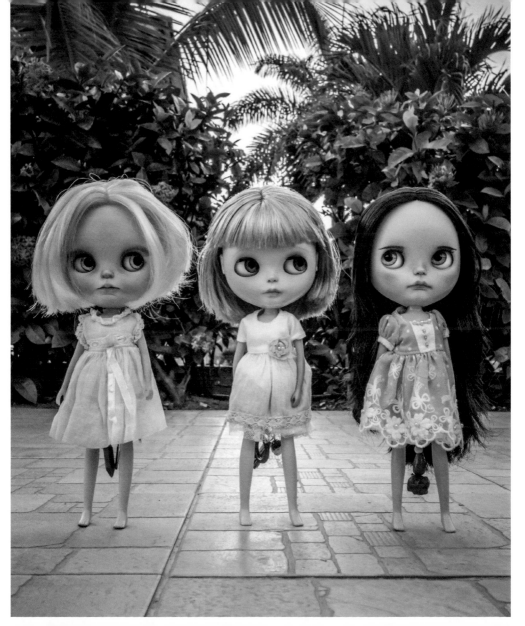

The Ferris Wheel

Ricky : "Ehhhhh... I think I changed my mind about that ride, Mom."

Me : "Seriously??! It's all you talked about in the car on the way here!"

Ricky : "Yeah.. I didn't realize how high it was. That's really high... What if a bird flies into my face and I get scared and I accidentally fall out! Plus, I don't think there's seatbeats!!"

Me : "You don't need seatbelts. It doesn't go fast. Just sit still. I think you can sit still for a few minutes.."

Ricky : "Wow. I'd like to see YOU sit still with a bird flying into YOUR face!!"

Me : "omg."

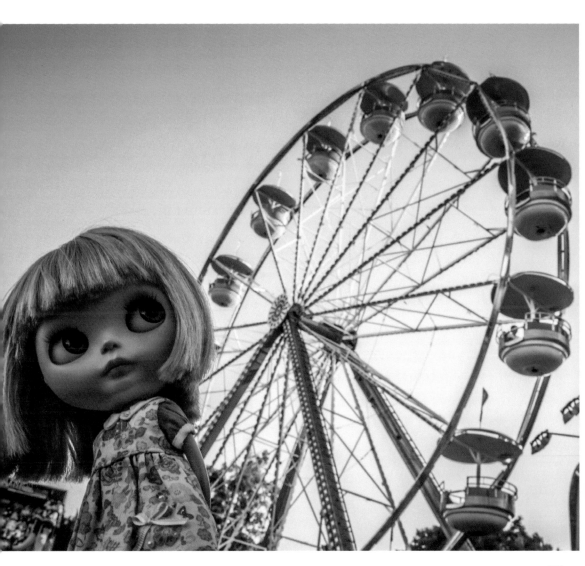

Closing Time

Me : "C'mon Ricky. We've got to go home now.
The library is closed."

Ricky : "I like being in the library after it closes..."

Me : "And why is that?"

Ricky : "Because I can pretend I'm anywhere.
I'm surrounded by stories.. And it's quiet.
My imagination can go so many places.
It's magical here, I think..."

Me : "I think so too."

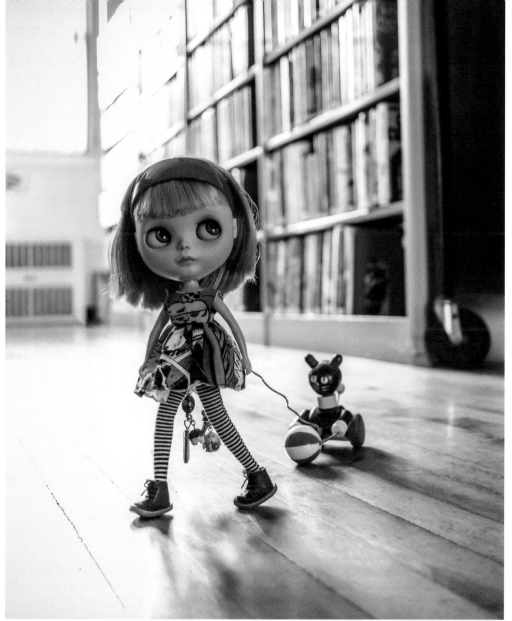

About the Author

Heidi is a doll customizer, a toy photographer,
and a journalist of little plastic thoughts. Her family shares
her passion and doesn't mind being dragged around the
world for dolly photo ops. During the day she can be found
'working' at her local public library.
She is a graduate of the School of Visual Arts in NYC.

Lightning Source UK Ltd.
Milton Keynes UK
UKIC032259101218
333790UK00001B/75